June 2004 -

Happy Birthday.

Let's live each

moment as delivered

on 13 33.

Love,

Don

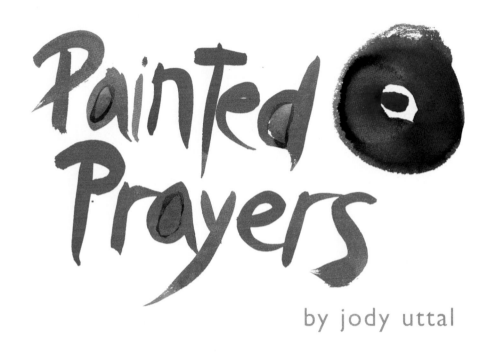

Painted Prayers

by jody uttal

tallfellow/everypicture press • los angeles

the idea for this book came from sketches I made when my mother was terminally ill.

I painted in bound watercolor books, working loosely – using bright, abstract images and hand painted words. although I am an artist, these paintings were in no way intended to be art. for me, the directness of the watercolor helped me stay present with my experience, and the work became a document of that incredibly important time.

I created dozens of pages of this "painted journal" during my mother's illness. after her death, I edited a collection of the pages, copied them on a laser printer and bound them. I began to share the "book" with the friends and family who were with me during my mother's last days. I presented it to a class on death and dying and shared it with healing groups. I began using this painted journal process to help others through their difficult times.

the painted journal provided a private space for me to process the experience of my mother's death. the immediacy of the paint and the brush strokes allowed me to work through the painful grieving period. stephen mitchell's *a book of psalms* brought me solace and I began to paint my interpretations of his words. these became the first painted prayers. I looked for other words that inspired me, and my search led me to pieces from many denominations and various cultures. If there is one theme throughout, it is that each written work captured a part of me, and my brush strokes responded accordingly. as one uses the words of prayer and poetry as an opening to go inside oneself, I hope the painted images will provide another vehicle to do the same. the chapter headings are intended only as a guide to that process.

my deepest regret is that my mother never saw this book or my subsequent work. I am grateful that we resolved many things between us before her death and I feel fortunate that I now have this work to share with others.

I hope the paintings and their accompanying words bring you as much comfort and healing as they have brought to me.

jody uttal
los angeles, 2002

published by
tallfellow press, inc. /every picture press, inc.
1180 s. beverly drive
los angeles, ca 90035

isbn 1-931290-02-4

printed in italy

designed by mick haggerty

10 9 8 7 6 5 4 3 2

visit www.paintedprayers.com
and
www.tallfellowpress.com

this book is dedicated to the memory of my parents
pamela defrece uttal and larry uttal

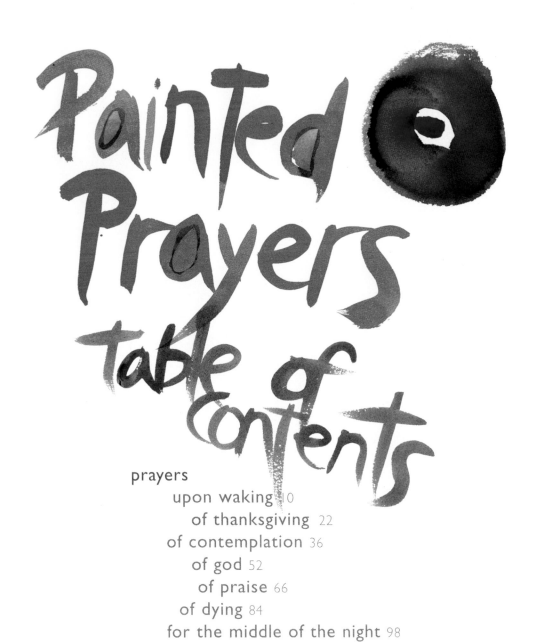

Painted Prayers

table of contents

prayers upon **waking**

waking up

waking up this morning, I smile.
twenty-four brand new hours are before me.
I vow to live fully in each moment
and to look at all beings with eyes of compassion.

thich nhat hanh

Lord the air smells good today

lord, the air smells good today,
straight from the mysteries
within the inner courts of god.
a grace like new clothes thrown
across the garden, free medicine for everybody.
the trees in their prayer, the birds in praise,
the first blue violets kneeling.
whatever came from being is caught up in being, drunkenly
forgetting the way back.

rumi

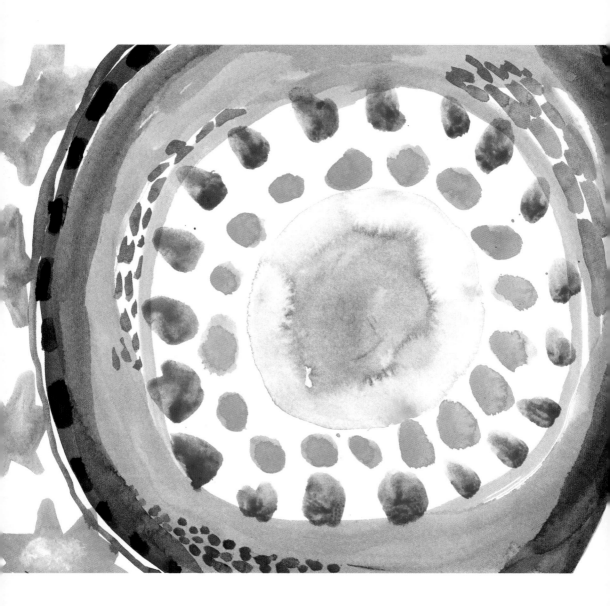

oh divine one,
the soul you have placed within me is pure.
you have created it,
you have fashioned it,
you have breathed it into me,
and you protect it within me.

hebrew prayer

master of the universe
grant me the ability to be alone;
may it be my custom to go outdoors each day
among the trees and grasses, among all growing things.
and there may I be alone and enter into prayer,
to talk with the one to whom I belong;
may I express there everything in my heart.
and may all the foliage of the field,
all grasses, trees and plants,
may they all awake at my coming,
to send the power of their life
into the words of my prayer,
so that my prayer and speech are made whole
through the life and spirit of all growing things,
which are made as one by their
transcendent source.

reb nachman of bratslav

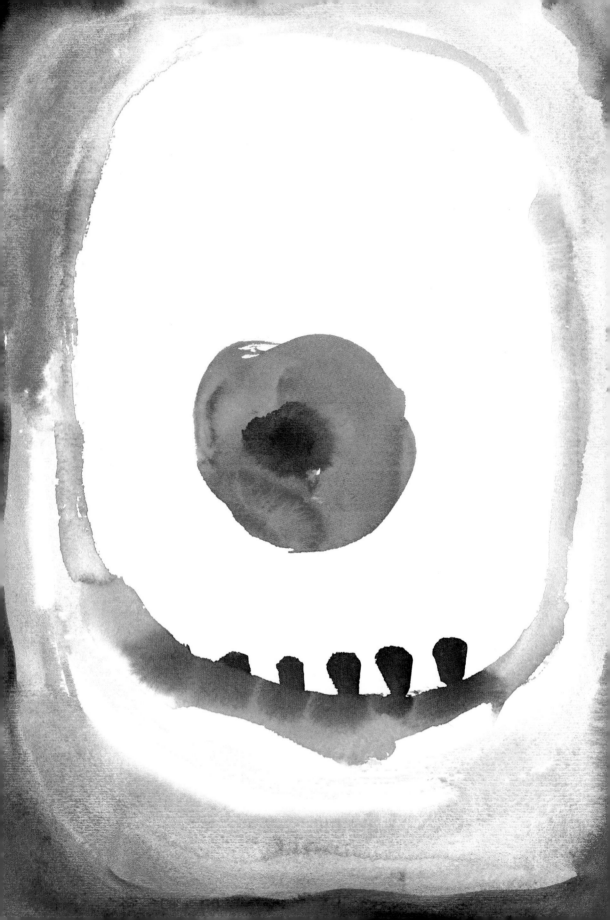

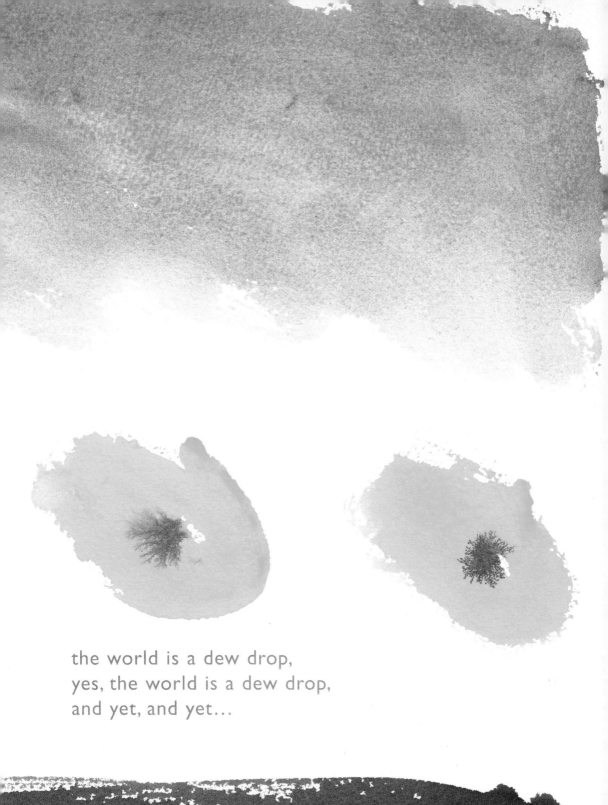

the world is a dew drop,
yes, the world is a dew drop,
and yet, and yet...

issa

prayers of **thanksgiving**

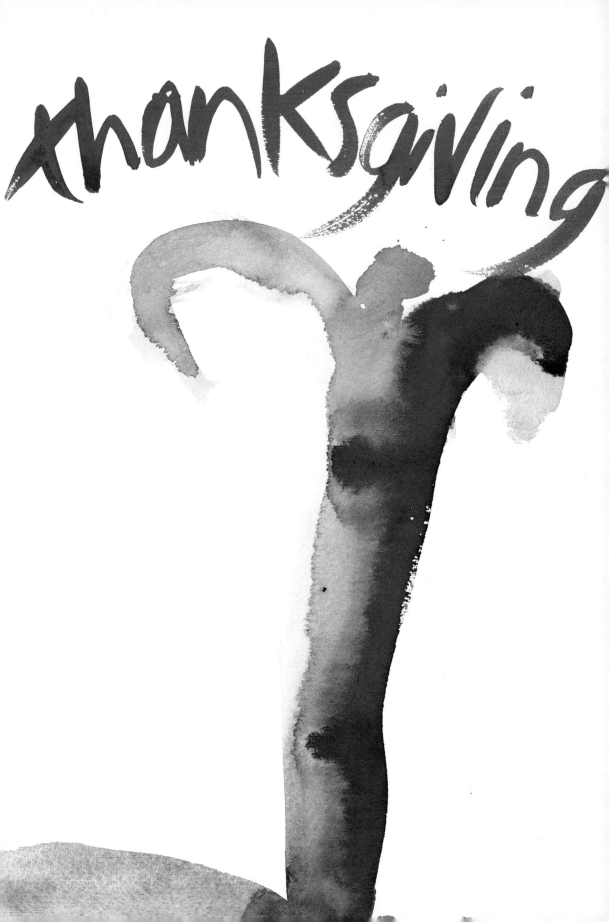

and god saw everything that god had made,
and behold, it was very good.

book of genesis

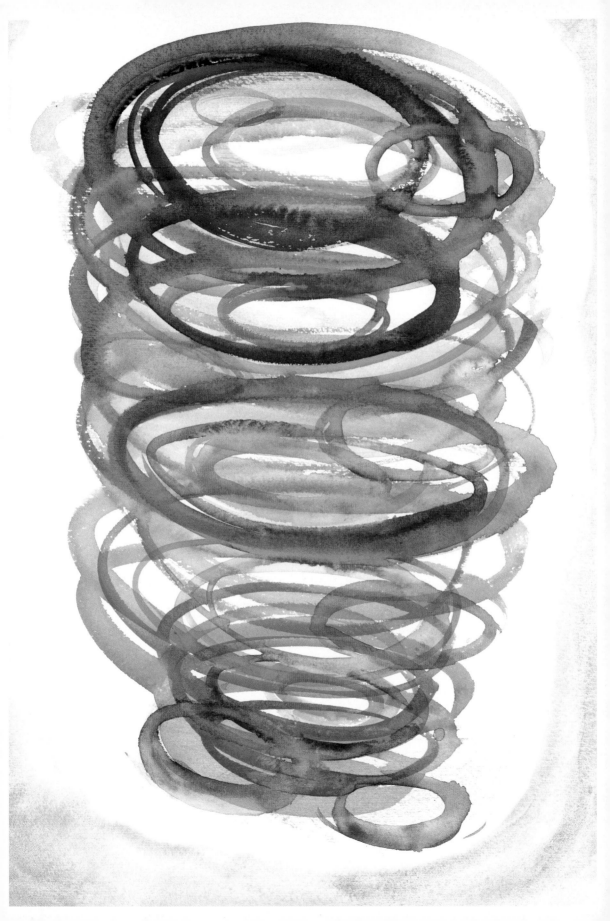

inside this clay jar there are meadows and groves and the one who made them.

inside this jar there are seven oceans and innumerable stars, acid to test gold, and a patient appraiser of jewels.

inside this jar the music of eternity, and a spring flows from the source of all waters.

kabir says: listen, friend! my beloved master lives inside.

kabir

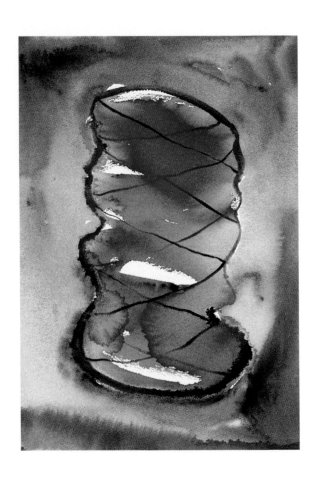

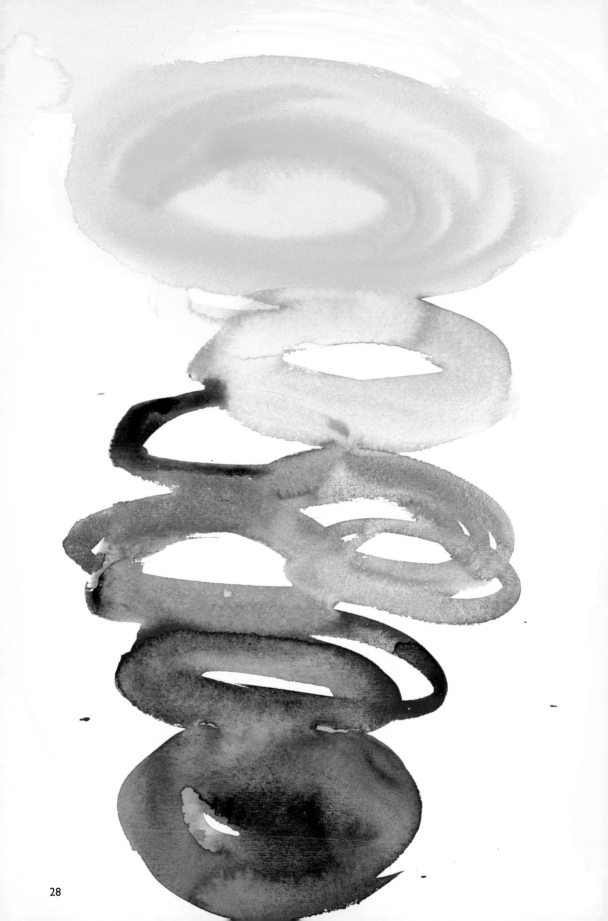

there are times when you are praying
in an ordinary state of mind
and you feel that you cannot draw near to god.
but then in an instant
the light of your soul will be kindled
and you will go up to the highest worlds.

you are like one who has been given a ladder:
the light that shines in you is a gift from above.

blessed is the divine one who has made our bodies with wisdom. veins, arteries, vital organs combined in a finely balanced system. wondrous fashioner and sustainer of life, source of our health and our strength, we give thanks.

hebrew prayer

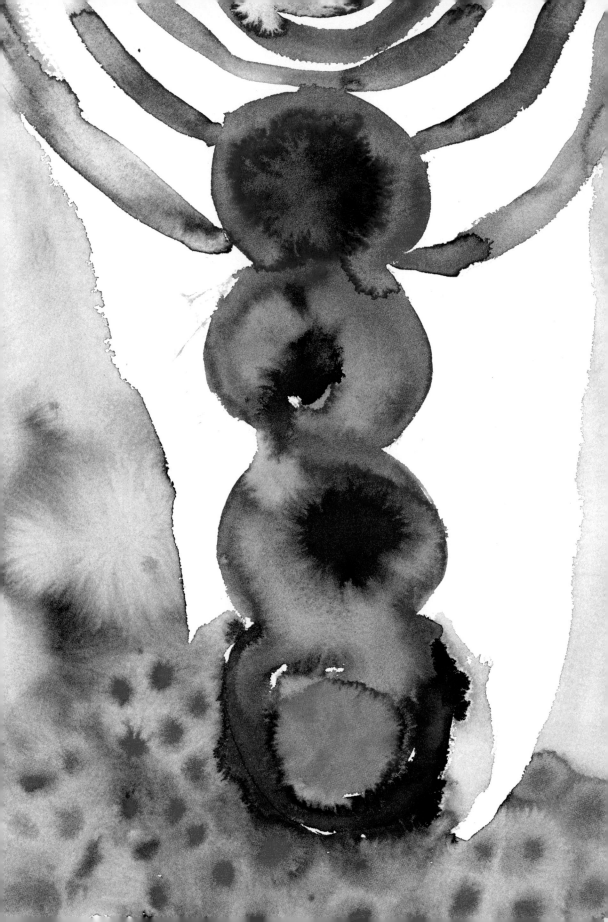

breathe

you are alive

following the breath

breathing in, I calm my body.
breathing out, I smile.
dwelling in the present moment,
I know this is a wonderful moment!

thich nhat hanh

the sun never says

even
after
all this time
the sun never says to the earth,

"you owe
me."

look
what happens
with a love like that,
it lights the
whole
sky.

hafiz

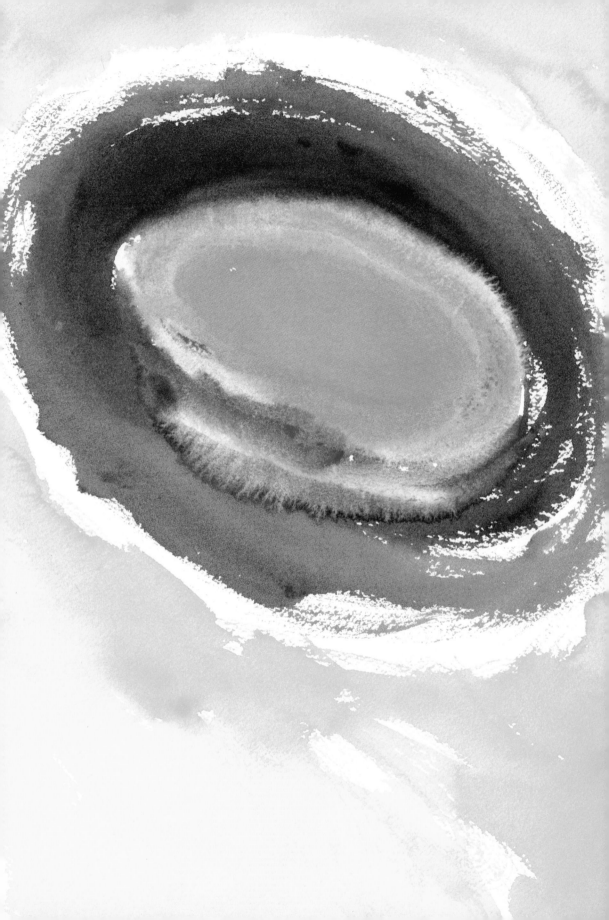

prayers of **contemplation**

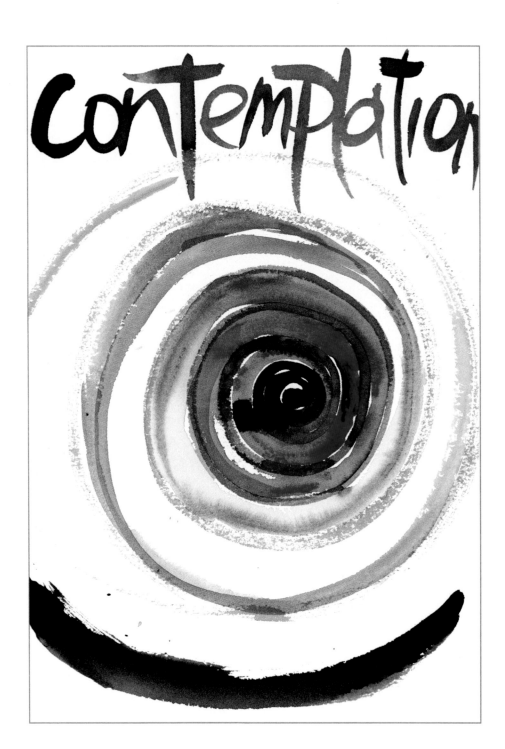

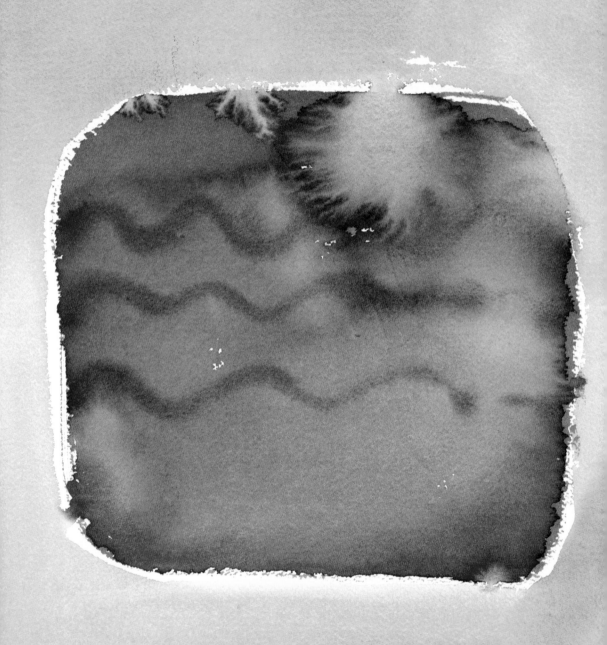

the guest house

this being human is a guest house.
every morning, a new arrival.

a joy, a depression, a meanness,
some momentary awareness comes
as an unexpected visitor.

welcome and entertain them all!
even if they're a crowd of sorrows,
who violently sweep your house
empty of its furniture,
still, treat each guest honorably.
he may be clearing you out
for some new delight.

the dark thought, the shame, the malice,
meet them at the door laughing,
and invite them in.

be grateful for whoever comes,
because each has been sent
as a guide from beyond.

rumi

when we understand,
we are at the center of the circle,
and there we sit while yes and no
chase each other around the circumference.

chuang-tzu

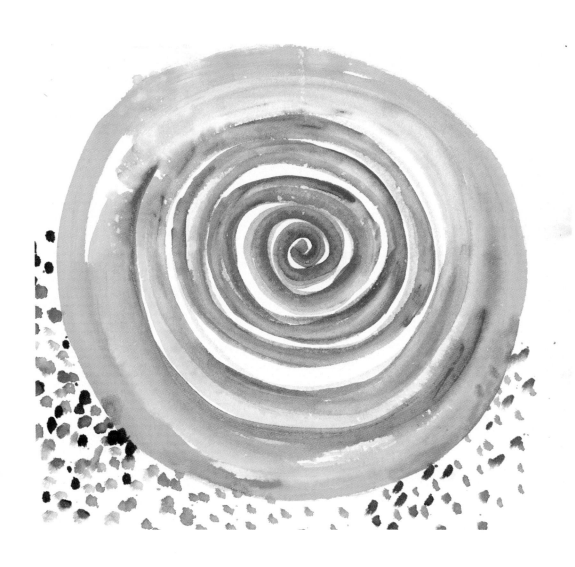

if I had a prayer, it would be this:

God,
Spare me from
the desire for
Love, approval,
and appreciation.
Amen.

byron katie

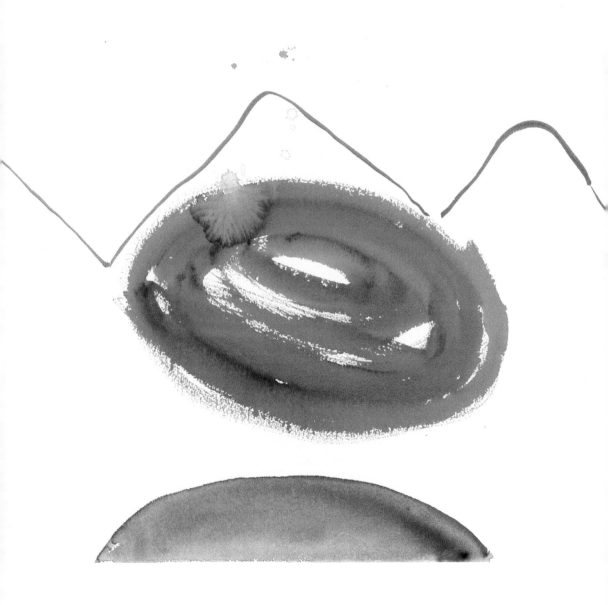

what is necessary, after all,
is only this: solitude,
vast inner solitude.
to walk inside yourself
and meet no one for hours —
that is what you must be able to attain.

rainer maria rilke

out beyond ideas of wrongdoing and rightdoing,
there is a field. I'll meet you there.

when the soul lies down in that grass,
the world is too full to talk about.
ideas, language, even the phrase *each other*
doesn't make any sense.

rumi

who speaks the sound of an echo?
who paints the image in a mirror?
where are the spectacles in a dream?
nowhere at all — that's the nature of mind!

tree-leaf woman

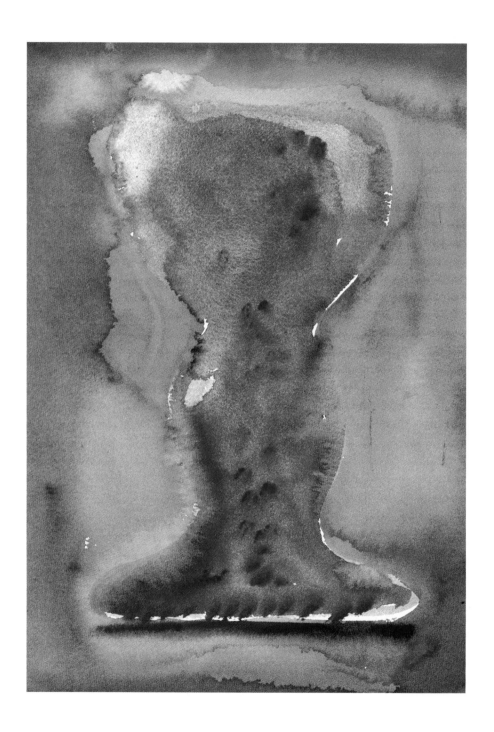

wisdom is
sweeter than honey,
brings more joy
than wine,
illumines
more than the sun,
is more precious
than jewels.
she causes
the ears to hear
and the heart to comprehend.

I love her
like a mother,
and she embraces me
as her own child.
I will follow
her footprints
and she will not cast me away.

makeba, queen of sheba

prayers of god

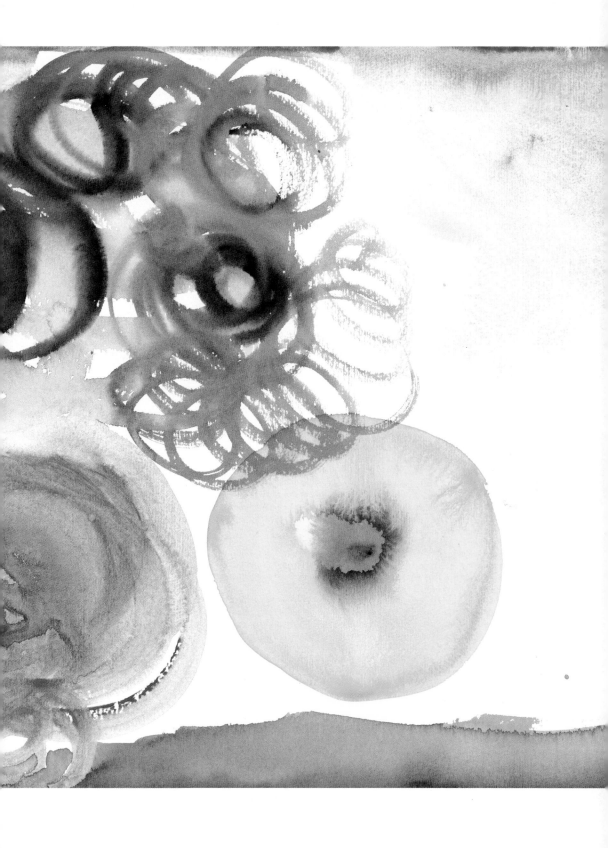

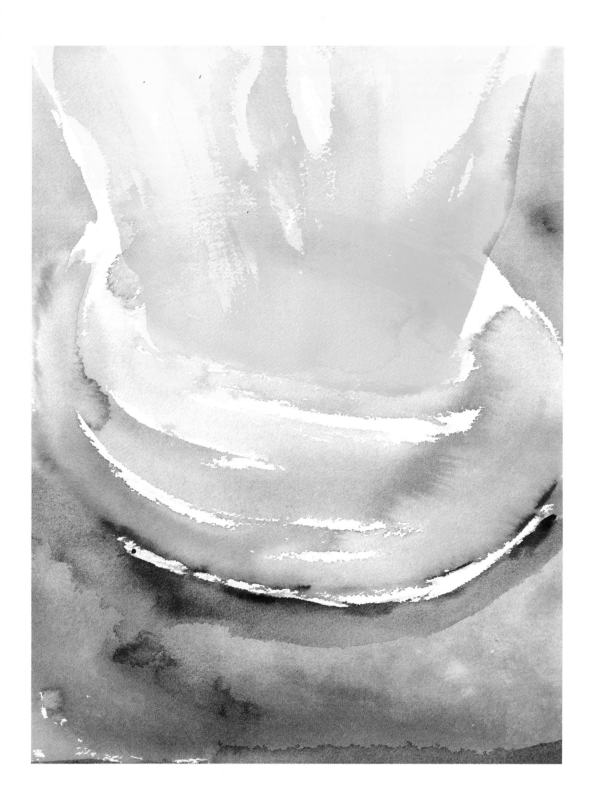

the eye through which I see god
is the same eye through which god sees me;
my eye and god's eye are one eye,
one seeing, one knowing, one love.

meister eckhart

there are times when the love of god
burns so powerfully within your heart
that the words of prayer seem to rush forth,
quickly and without deliberation.
at such times it is not you yourself who speak;
rather it is through you
that the words are spoken.

hasidic masters

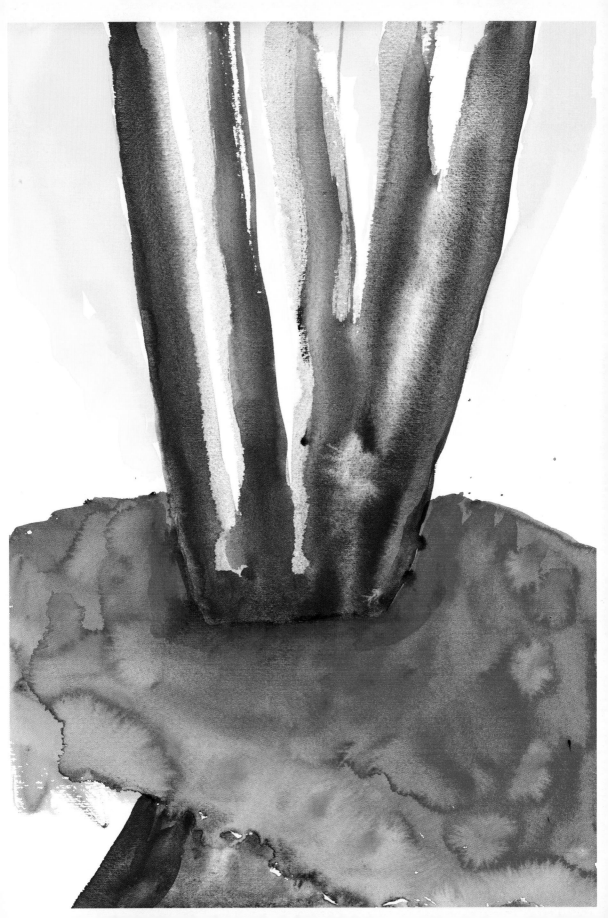

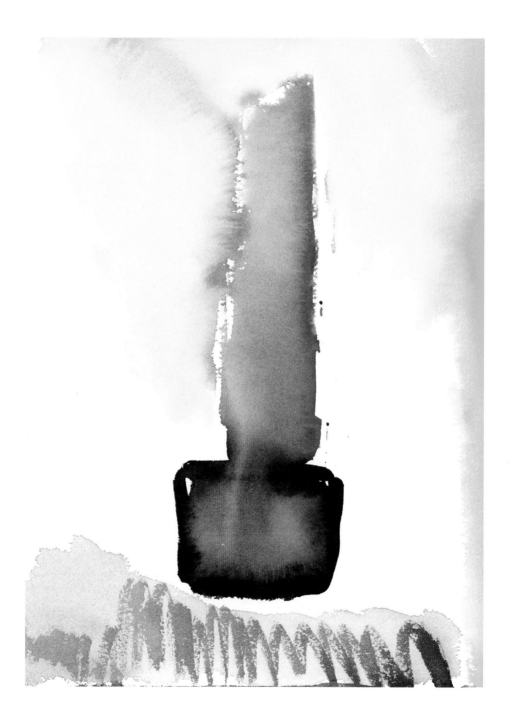

why am I reaching again for the brushes?
when I paint your portrait, god,
nothing happens.

but I can choose to feel you.

at my senses' horizon
you appear hesitantly,
like scattered islands.

yet standing here, peering out,
I'm all the time seen by you.

the choruses of angels use up all of heaven.
there's no more room for you
in all that glory. you're living
in your very last house.

all creation holds its breath, listening within me,
because, to hear you, I keep silent.

rainer maria rilke

the great way has no gate;
there are a thousand paths to it.
if you pass through the barrier,
you walk the universe alone.

wu-men

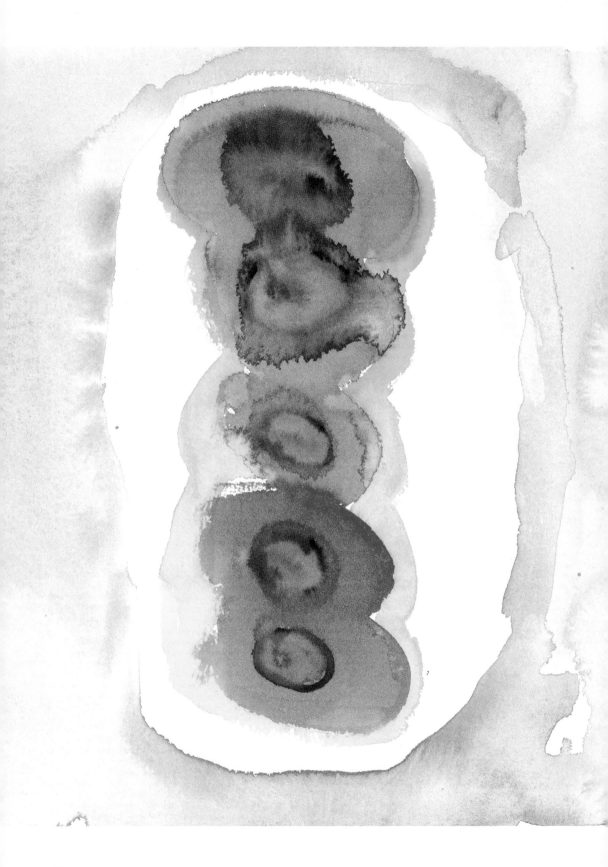

kabir says: student, tell me, what is god?
he is the breath inside the breath.

kabir

the kingdom of god does not come if you watch for it. nor will anyone be able to say, "it is here" or "it is there." for the kingdom of god is within you.

jesus of nazareth

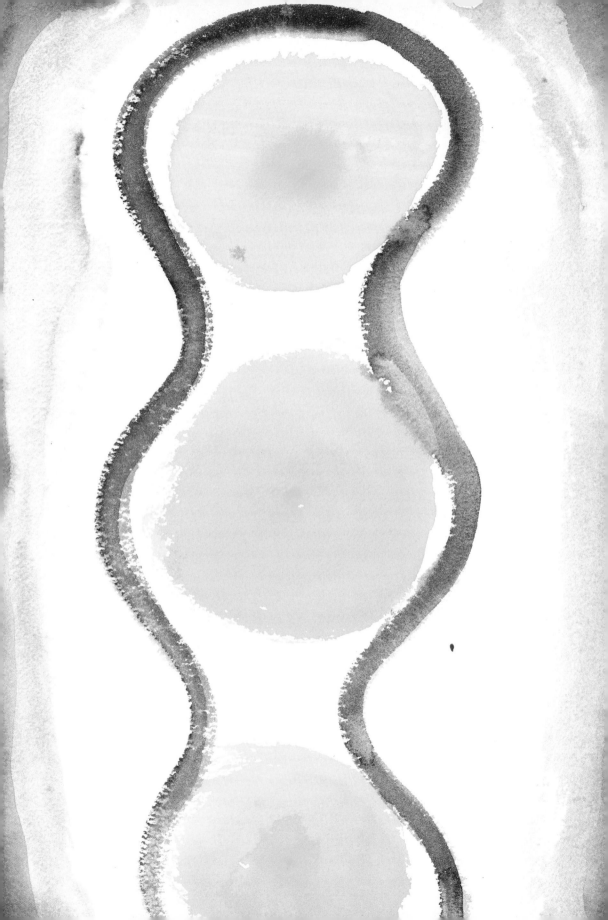

prayers of praise

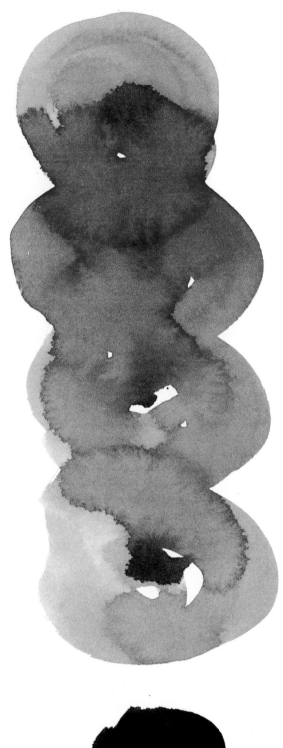

holy are you, your name is holy,
and all holy beings hail you each day.
blessed are you, the awesome one, the holy god.

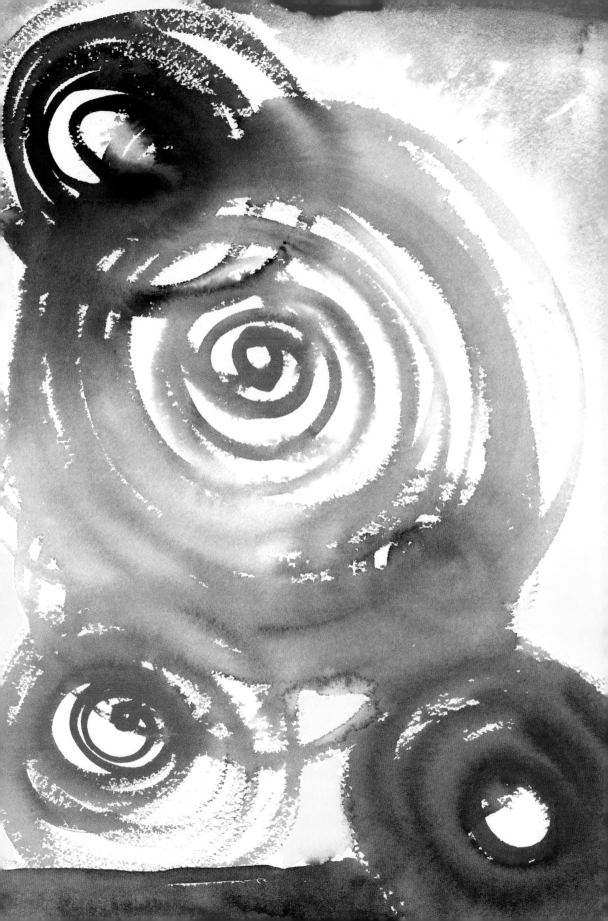

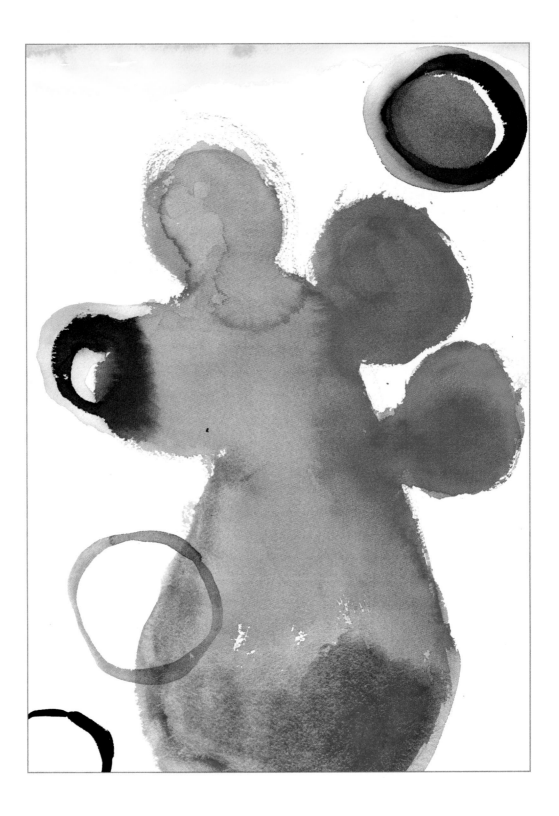

god is alive
magic is afoot

god is alive
magic is afoot

god is afoot
magic is alive

alive is afoot
magic never died

leonard cohen

God acts within
every moment

and creates the
World with
each breath.

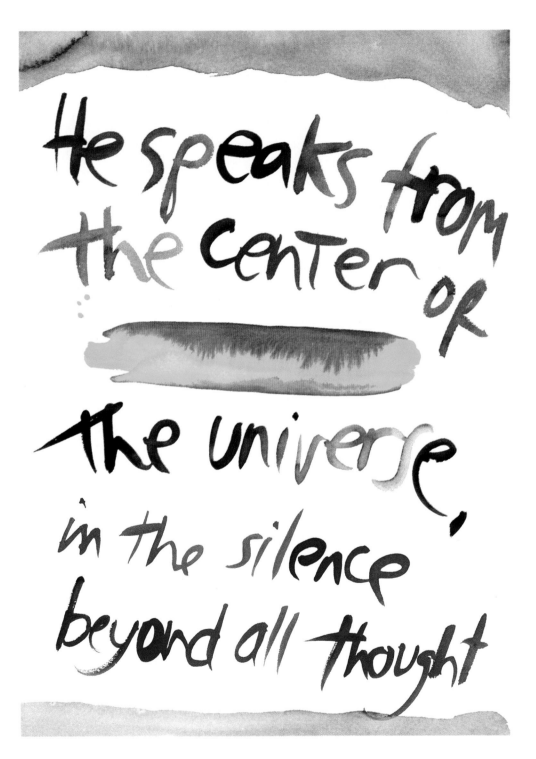

He speaks from the center of the universe, in the silence beyond all thought

adapted from the hebrew by stephen mitchell

holy spirit,
giving life to all life,
moving all creatures,
root of all things,
washing them clean,
wiping out their mistakes,
healing their wounds,
you are our true life,
luminous, wonderful,
awakening the heart
from its ancient sleep.

hildegard of bingen

you follow me everywhere,
weaving a web of visions around me
blinding my sightless spine like a sun

you follow me like an enveloping forest
and continuously astonish my lips into awesome silence
like a child lost in ancient sanctuary

you follow me like a tremor.
I want to rest. you demand: come,
see how visions lie scattered aimlessly in the streets.

o wander, deep in my own fantasies, like a secret,
down a long corridor through the world.
now and then, high above me, I catch a glimpse of the
faceless face of you.

abraham joshua heschel

I pray for whatever you send me, and I ask to receive it as your gift

psalm 4

even in the midst of great pain, lord,
I praise you for that which is.
I will not refuse this grief
or close myself to this anguish.
let shallow men pray for ease:
"comfort us; shield us from sorrow."
I pray for whatever you send me,
and I ask to receive it as your gift.
you have put a joy in my heart
greater than all the world's riches.
I lie down trusting the darkness,
for I know that even now you are here.

adapted from the hebrew by stephen mitchell

I have learned so much from God

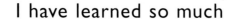

I have learned so much

I
have
learned
so much from god
that I can no longer
call
myself

a christian, a hindu, a muslim,
a buddhist, a jew.

the truth has shared so much of itself
with me

that I can no longer call myself
a man, a woman, an angel,
or even pure
soul.

love has
befriended hafiz so completely
it has turned to ash
and freed
me

of every concept and image
my mind has ever known.

Hafiz

psalm 23

the lord is my shepherd:
I have everything that I need.
he makes me lie down in green pastures;
he leads me beside the still waters;
he refreshes my soul.
he guides me on the paths of righteousness,
so that I may serve him with love.
though I walk through the darkest valley
or stand in the shadow of death,
I am not afraid,
for I know you are always with me.
you spread a full table before me,
even in times of great pain;
you feast me with your abundance
and honor me like a king,
anointing my head with sweet oil,
filling my cup to the brim.
surely goodness and mercy will follow me
all the days of my life,
and I will live in god's radiance
forever and ever.

adapted from the hebrew by stephen mitchell

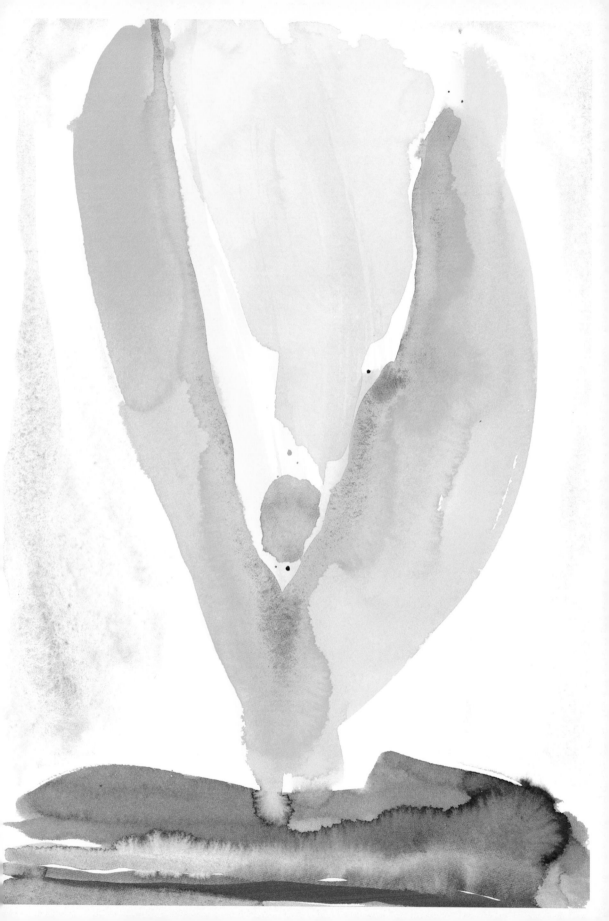

prayers of dying

Dying

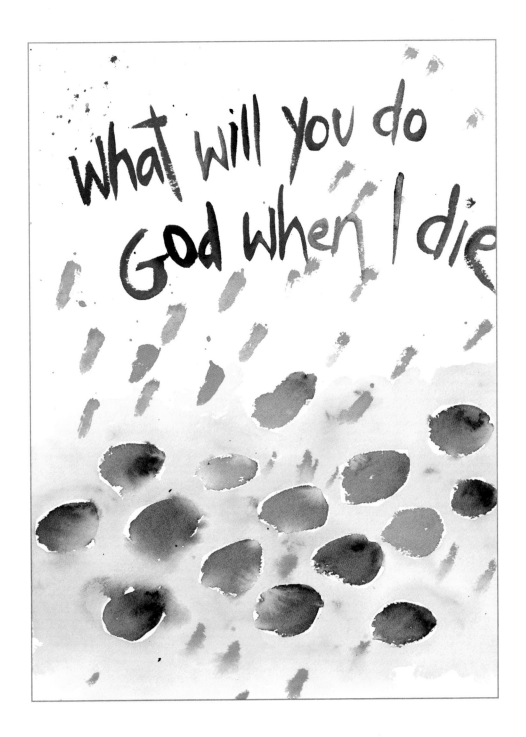

what will you do, god, when I die?

I am your pitcher (when I shatter?)
I am your drink (when I go bitter?)
I, your garment; I, your craft.
without me what reason have you?

without me what house
where intimate words await you?
I, velvet sandal that falls from your foot.
I, cloak dropping from your shoulder.

your gaze, which I welcome now
as it warms my cheek,
will search for me hour after hour
and lie at sunset, spent,
on an empty beach
among unfamiliar stones.

what will you do, god? I am afraid.

rainer maria rilke

don't grieve.
anything you lose comes around in another form.
the child weaned from mother's milk
now drinks wine and honey mixed.
god's joy moves from unmarked box to unmarked box,
from cell to cell.
as rainwater,
down into flowerbed.
as roses, up from ground.
now it looks like a plate of rice and fish,
now a cliff covered with vines,
now a horse being saddled.
it hides within these,
till one day it cracks them open.

...ta dum dum, taa dum, ta ta dum.
there's the light gold of wheat in the sun,
and the gold of bread made from wheat...
I have neither, I am only talking about them.

as a town in the desert looks up
to stars on a clear night.

rumi

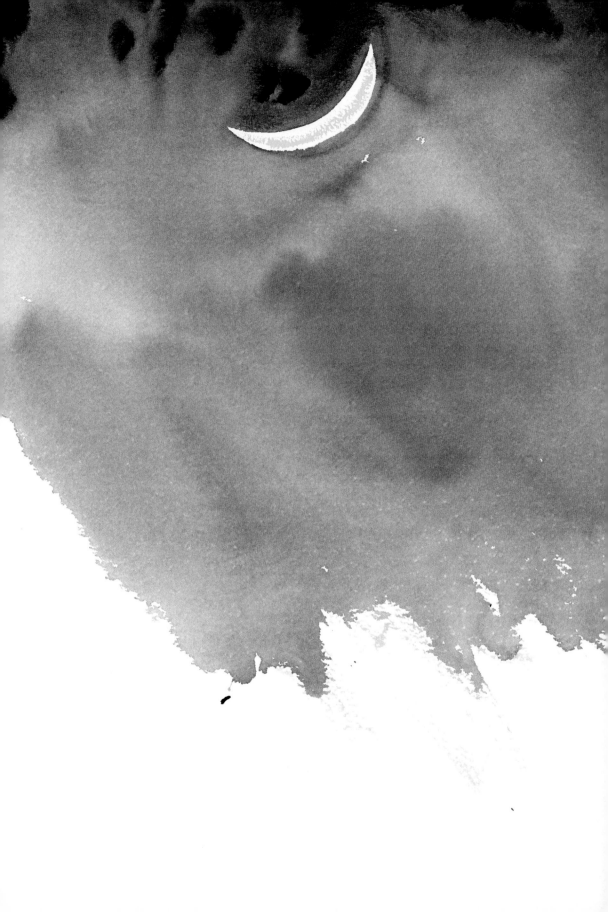

sometimes, when a bird cries out,
or the wind sweeps through a tree,
or a dog howls in a far-off farm,
I hold still and listen a long time.

my world turns and goes back to the place
where, a thousand forgotten years ago,
the bird and the blowing wind
were like me, and were my brothers.

my soul turns into a tree,
and an animal, and a cloud bank.
then changed and odd it comes home
and asks me questions. what should I reply?

hermann hesse

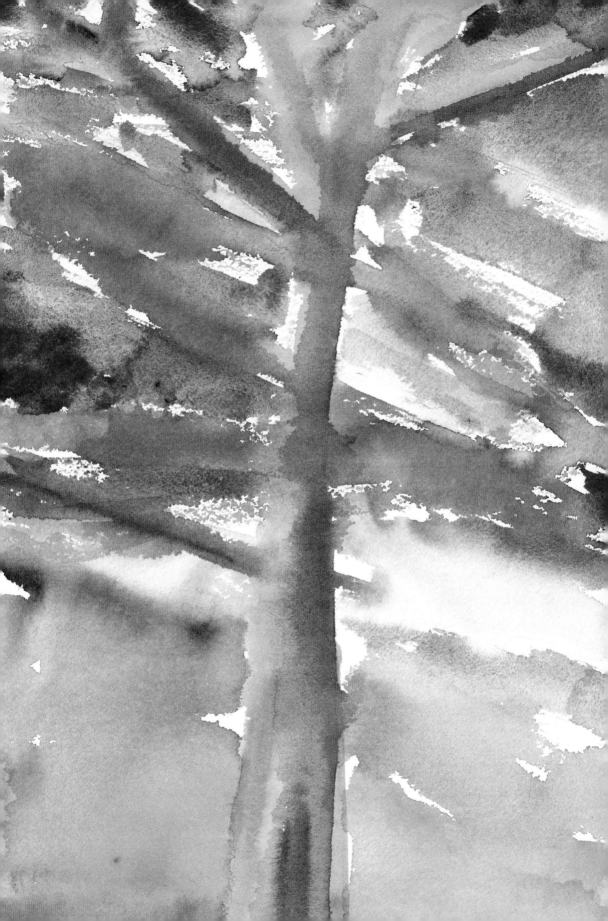

never the spirit is born
the spirit will cease to be never
never the time when it was not.
end and beginning are dreams
birthless and deathless and changeless
remains the spirit forever.
death has not touched it at all
dead though the house of it seems.

sioux prayer of passing

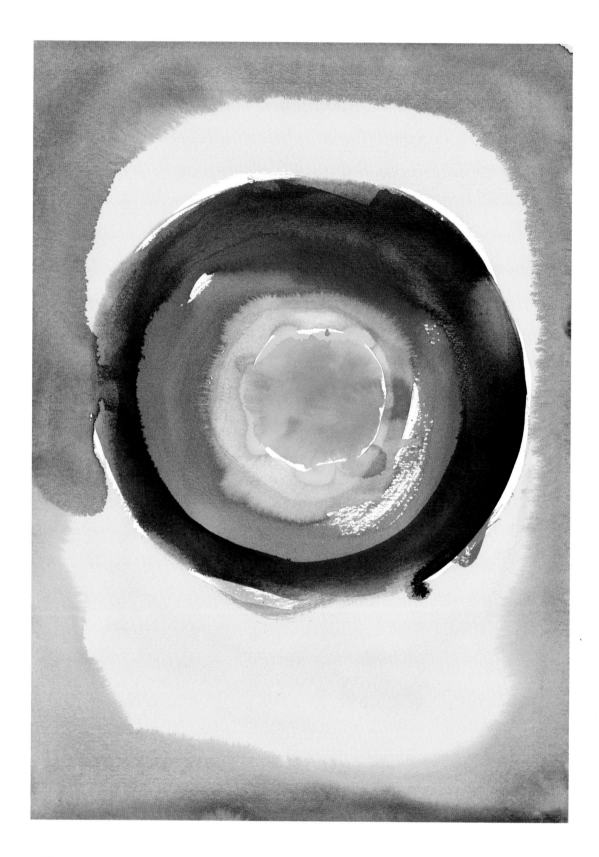

you would know the secret of death.
but how shall you find it unless you seek
it in the heart of life?
the owl whose night bound eyes are
blind unto the day cannot unveil the mystery
of light.

if you would indeed behold the spirit of
death, open your heart wide unto the body
of life.
for life and death are one, even as the
river and sea are one.

kahil gibran

birth, old age,
sickness, and death:
from the beginning,
this is the way
things have always been.
any thought
of release from this life
will wrap you only more tightly
in its snares.
the sleeping person
looks for a buddha,
the troubled person
turns toward meditation.
but the one who knows
that there's nothing to seek
knows too that there's nothing to say.
she keeps her mouth closed.

ly ngoc kieu

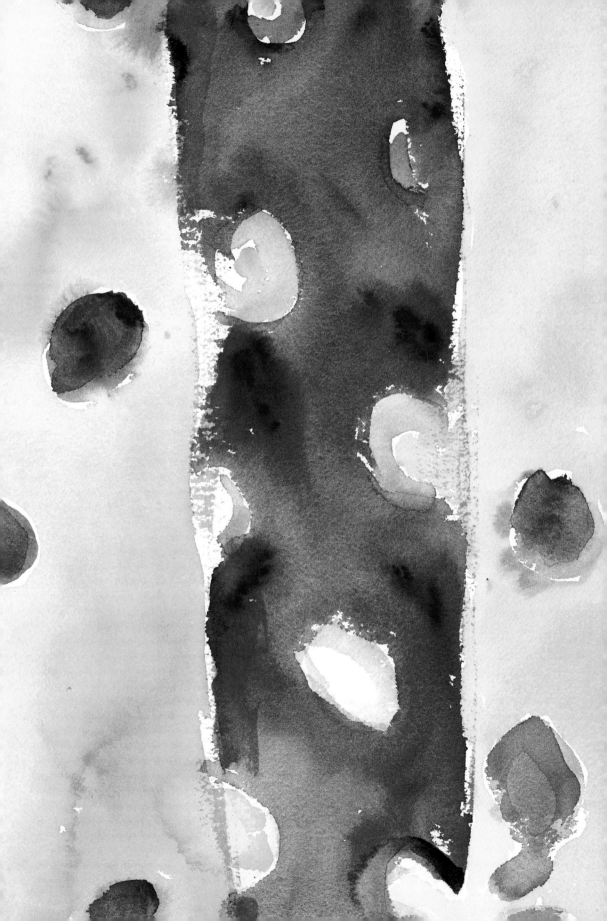

prayers for the middle of the night

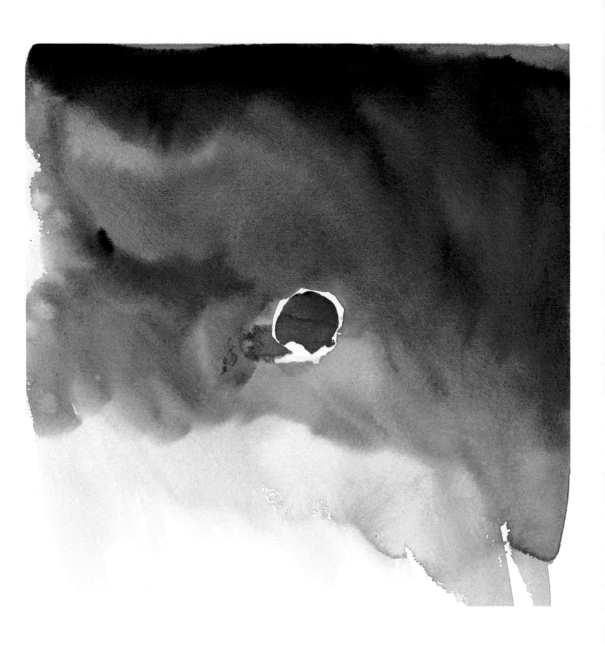

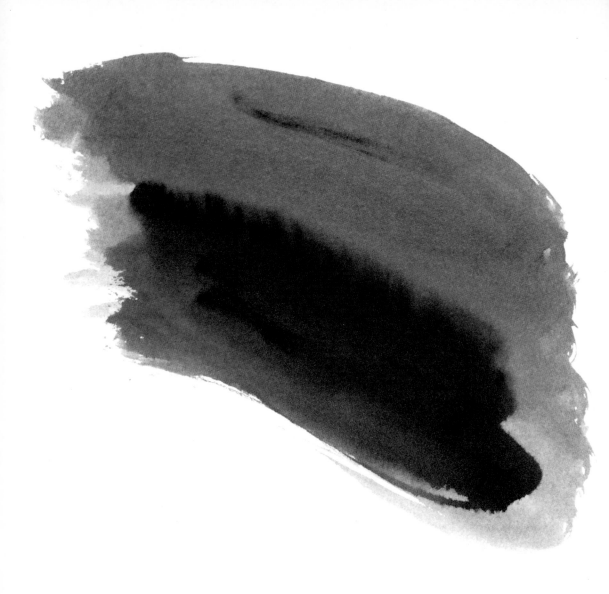

on the treasury of the true dharma eye

midnight. no waves,
no wind, the empty boat
is flooded with moonlight.

dogen

you, darkness, of whom I am born —

I love you more than the flame
that limits the world
to the circle it illumines
and excludes all the rest.

but the dark embraces everything:
shapes and shadows, creatures and me,
people, nations — just as they are.

it lets me imagine
a great presence stirring beside me.

I believe in the night.

rainer maria rilke

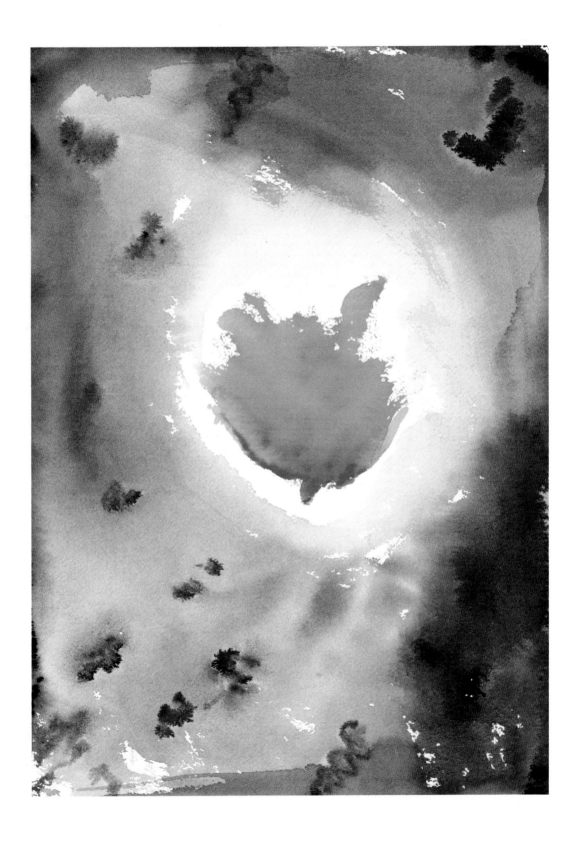

Do not forsake us

hear our voice, lord our god; spare us, pity us,
accept our prayer in your gracious love.

turn us to you, o lord, and we shall return;
renew us as in days of old.

do not banish us from your presence;
do not deprive us of your holy spirit.

do not cast us off in old age;
when our strength declines, do not forsake us.

do not forsake us, o lord our god;
do not make yourself distant from us.

hebrew prayer

I have lived on the lip
of insanity, wanting to know reasons,
knocking on a door. it opens.
I've been knocking from the inside!

rumi

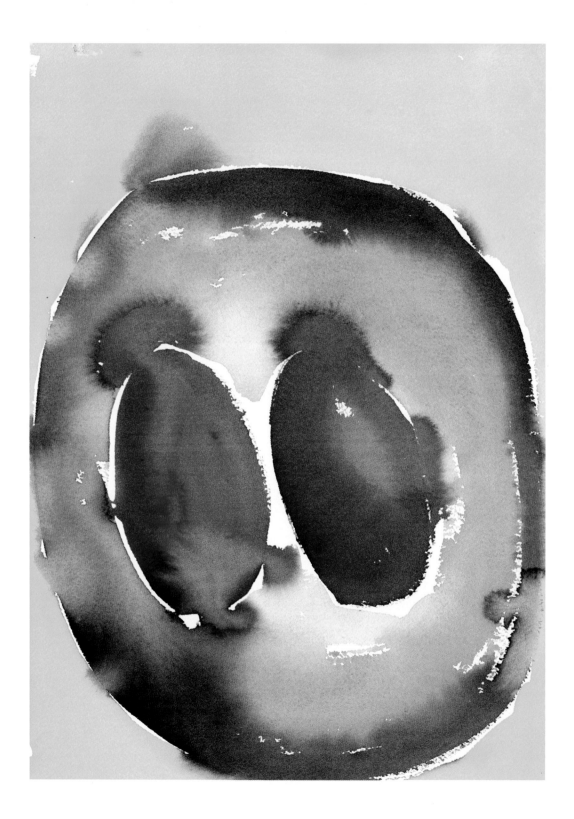

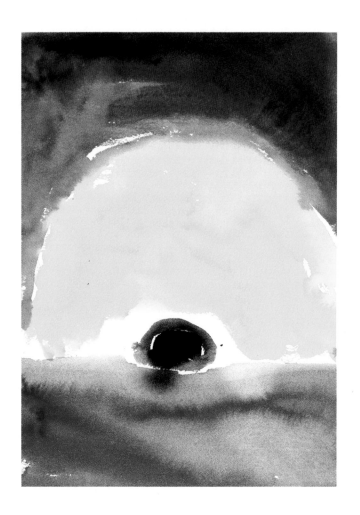

watching the moon
at midnight,
solitary, mid-sky,
I knew myself completely,
no part left out.

izumi shikibu

you, god, who live next door —

if at times, through the long night, I trouble you
with my urgent knocking —
this is why: I hear you breathe so seldom.
I know you're all alone in that room.
if you should be thirsty, there's no one
to get you a glass of water.
I wait listening, always. just give me a sign!
I'm right here.

as it happens, the wall between us
is very thin. why couldn't a cry
from one of us
break it down? it would crumble
easily,

it would barely make a sound.

rainer maria rilke

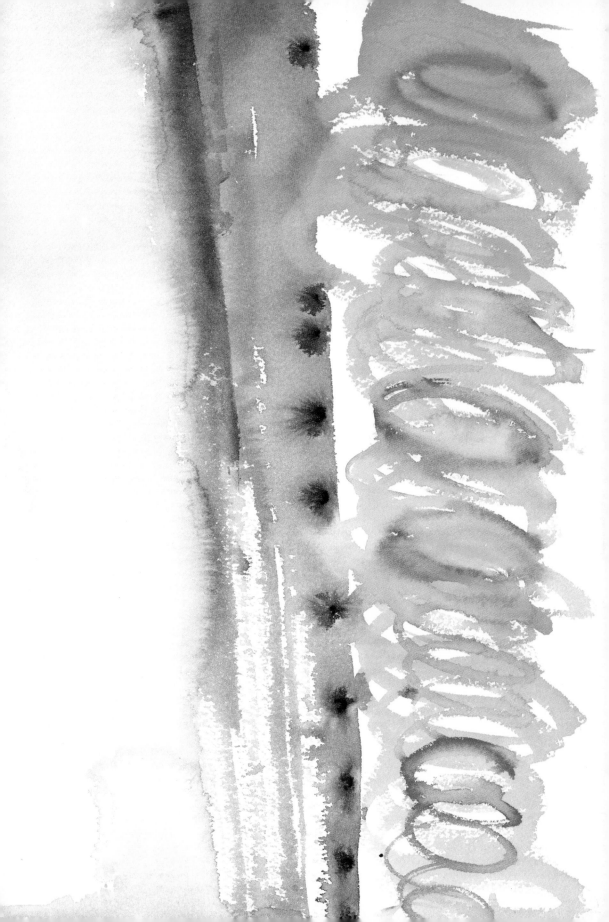

prayers of renewal

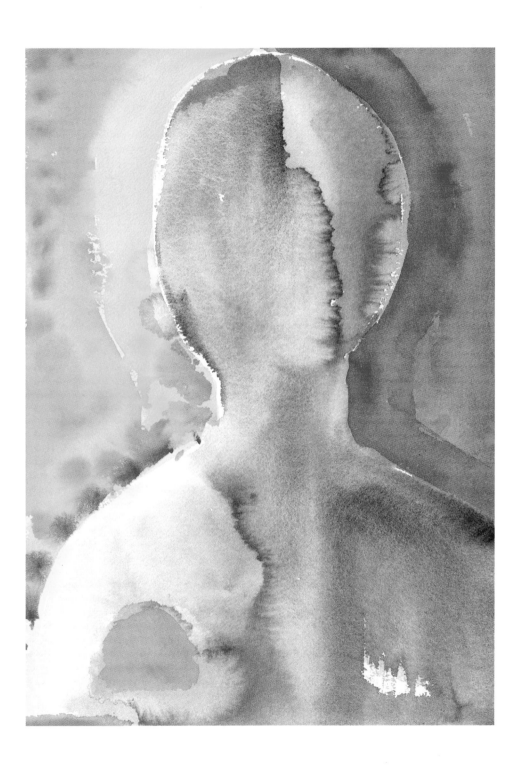

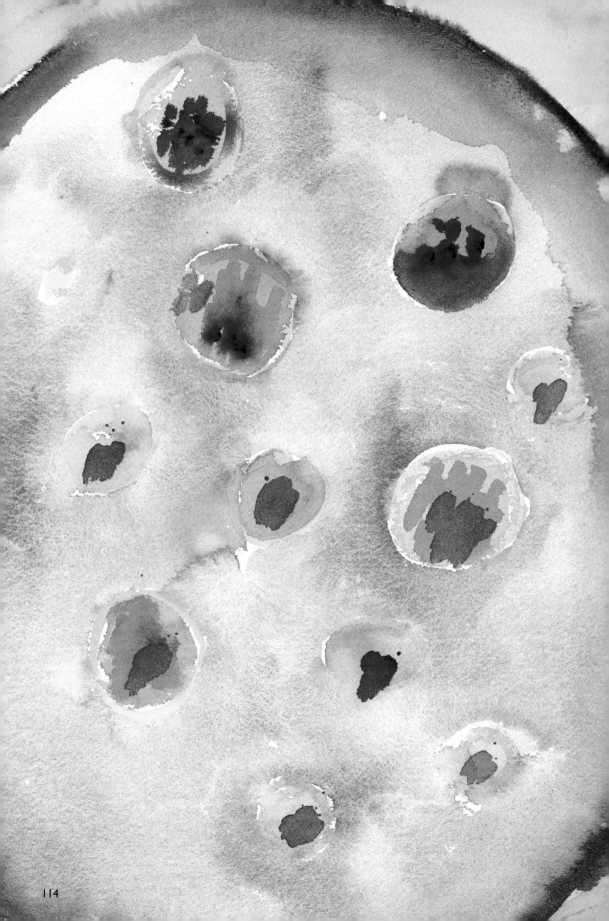

looking at your hand
whose hand is this
that has never died?
who is it who was born in the past?
who is it who will die in the future?

thich nhat hanh

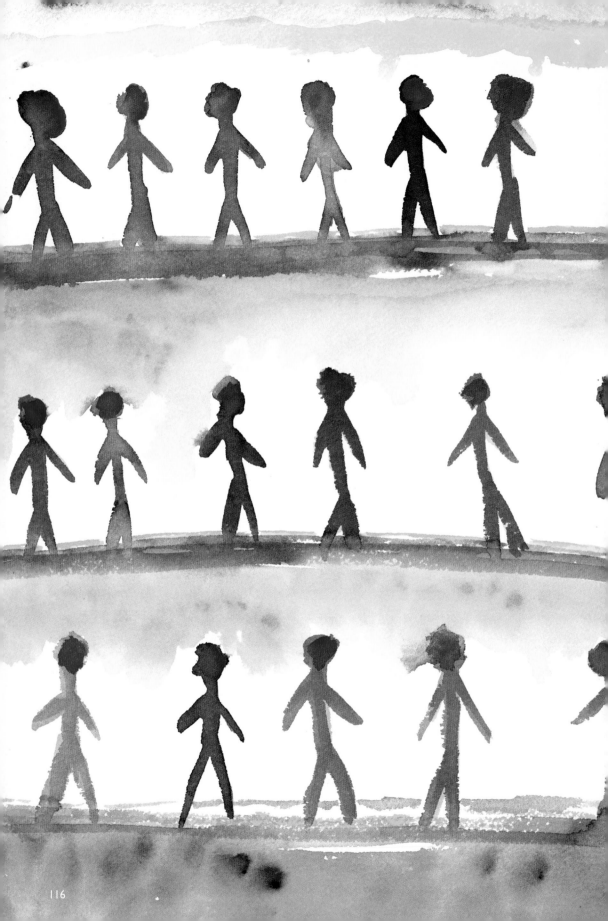

choice

are we chosen by our life, or do we have a choice?
our tasks choose us, or so it often seems.
are we silent behind inner walls, or do we have a voice?
chosen and elected, can we shape our dreams?
hope or despair? isaiah chose hope;
love was hosea's choosing.
moses chose freedom, risking pharoah's rope:
in arid desert waste, a people fusing.
how we meet the surge of life, this inner stance is ours,
to greet the roistering days with wonder at creation.
the hands we use, the words we say in dark or shining hours
strengthen us to face each day in affirmation.
we who now elect to act, in this present filled with strife,
open ourselves to hope, as we choose life.

norma uttal levitt

psalm 1

blessed are the man and the woman
who have grown beyond their greed
and have put an end to their hatred
and no longer nourish illusions,
but they delight in the way things are
and keep their hearts open, day and night.
they are like trees planted near flowing rivers,
which bear fruit when they are ready.
their leaves will not fall or wither.
everything they do will succeed.

adapted from the hebrew by stephen mitchell

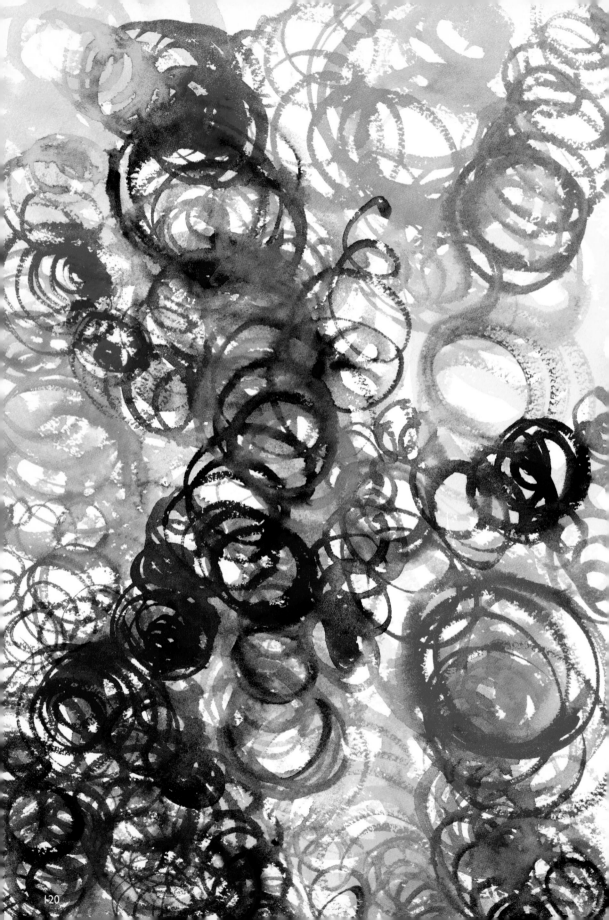

may you live to see your world fulfilled,
may you be our link to future worlds,
and may your hope encompass
all the generations yet to be.
may your heart conceive with understanding,
may your mouth speak wisdom,
and your tongue be stirred with sounds of joy.

renewal

an epiphany enables you to sense creation
not as something completed, but as
constantly becoming, evolving, ascending.
this transports you from a place where there
is nothing new to a place where there
is nothing old, where everything renews itself,
where heaven and earth rejoice as at the moment
of creation.

abraham isaac kook

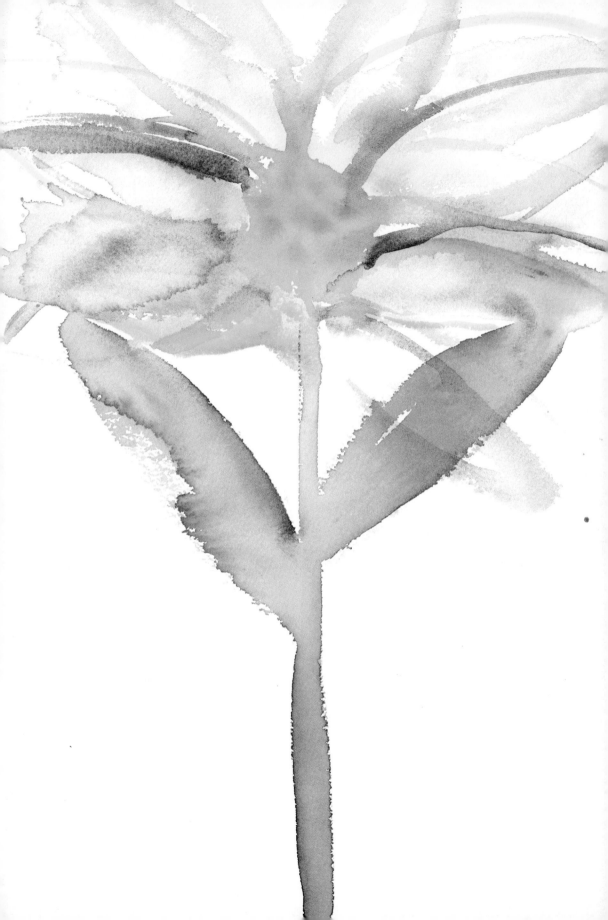

inspirational sources

COLEMAN BARKS (trans., Rumi) published his first book of poetry, The Juice, in 1972. He is primarily known for his translations of the poetry of Rumi.

ANITA BARROWS (trans., Rilke) is a poet, translator and child psychologist who practices in Berkeley, California.

ROBERT BLY (trans., Meister Eckhart, Hesse) is an internationally-known poet, translator and academic who is often credited for reinvigorating the American interest in letters. He was the recipient of the 1969 National Book Award and is now best known for his work studying male aggression.

CHUANG-TZU, who died in approximately 286 B.C.,was a Chinese philosopher, Taoist Master and comedian.

LEONARD COHEN is a world-renowned songwriter and performer, as well as the author of the acclaimed novel Beautiful Losers.

DOGEN was a thirteenth-century Japanese Zen Master, poet, philosopher, painter and the founder of the Soto Zen School in Japan. Biographers state that Dogen experienced his first religious revelation at the age of seven, while grieving the death of his mother.

MEISTER ECKHART, a thirteenth-century German priest and theologian, is said to be one of the greatest Christian teachers.

KAHLIL GIBRAN was a Lebanese poet, philosopher and artist whose written works have been translated into more than twenty languages. His visual art has been exhibited throughout the world, drawing comparisons to that of Auguste Rodin and William Blake.

ARTHUR GREEN (trans., Hasidic Masters) is the Lown Professor of Jewish Thought at Brandeis University and former President of the Reconstructionist Rabbinical College in Philadelphia. He is a student of Jewish theology and mysticism and the author of several books and articles on Judaism, spirituality and spiritual renewal.

HAFIZ, a fourteenth-century contemporary of Chaucer, is one of Persia's most beloved poets. When he died he was thought to have written over 5,000 poems, up to 700 of which have survived. His work has been known and respected by a variety of western writers, including Goethe, Emerson and Garcia Lorca.

THICH NHAT HANH is a Vietnamese Buddhist monk whose lifelong efforts to generate peace led Martin Luther King, Jr. to nominate him for the Nobel Peace Prize in 1967. Since the early 1980s he has lectured and lead retreats on mindful living. He currently lives and teaches in France.

ROBERT HASS (trans., Kabir) was the Poet Laureate of the United States from 1995-1997. He is an activist for literacy and the environment, and currently teaches English at the University of California at Berkeley. Hass has collaborated on numerous translations of Kabir with the poet Czeslaw Milosz.

ABRAHAM JOSHUA HESCHEL, one of the foremost Jewish thinkers of the twentieth century, was an internationally known scholar, author, activist and theologian. His major works are Man is Not Alone and God in Search of Man. Heschel also served as Professor of Ethics and Mysticism at the Jewish Theological Seminary of America.

HERMANN HESSE, a German-Swiss novelist, was awarded the Nobel Prize for literature in 1946. Hesse was a pacifist and a follower of Jungian psychology. His best-known works include Siddhartha, Demian and The Glass Bead Game.

HILDEGARD OF BINGEN, or Saint Hildegard, was sent to live in a Benedictine community in Germany at the age of eight. Throughout childhood she experienced visions and clairvoyance. Her books describing her visions were affirmed by Pope Eugenius III, and soon thereafter she became famous throughout Europe through a series of preaching tours into her sixties.

JANE HIRSHFIELD (trans., Ly Ngoc Kieu, Izumi Shikibu, Makeda, Queen of Sheba, Tree-Leaf Woman), a student of Zen, is an acclaimed poet and translator whose work has appeared in several national magazines and anthologies. She is the past recipient of a Guggenheim Fellowship and has published three collections of poetry.

BARRY HOLTZ (trans., Hasidic Masters) is the former co-director of the Melton Research Center for Jewish Education, where for twelve years he supervised the writing and publication of Melton Curriculum materials for Jewish schools across America. He is the editor and author of numerous books on Jewish studies.

ISSA was an eighteenth-century Japanese poet famous for his haiku. His work remained simple and positive in spite of a difficult life which included physical abuse, poverty and family tragedy.

JESUS OF NAZARETH was the prophet, healer and religious reformer upon whose life and teachings Christianity is based.

KABIR was a fifteenth-century Indian mystic, poet and weaver revered by Hindus and Moslems. Although he was illiterate and lived a quiet, provincial life, his poems lived on orally for centuries through popular song.

BYRON KATIE is the creator of *The Work*, a form of spiritual self-inquiry. She is currently collaborating on a book with Stephen Mitchell.

LY NGOC KIEU was an eleventh-century Zen Buddhist nun and the earliest known woman writer from Vietnam. The goddaughter of a king, she was married to a district chief. Upon his death she took religious vows and later served as the director of a temple.

ABRAHAM ISAAC KOOK was a 20th century Kabbalist. He died in 1935

DANIEL LADINSKY *(trans., Hafiz)*, a native of St. Louis, spent six years living in a spiritual community in western India. He has published three volumes of Hafiz's poetry in translation.

NORMA UTTAL LEVITT is a writer dedicated to international humanitarian concerns and multi-religious understanding. She has held leadership positions on a number of United Nations committees on religion and aging. A graduate of Wellesley College, The University of Chicago, and the University of California-Berkeley, she now resides in New Jersey.

JOANNA MACY, Ph.D. *(trans., Rilke)* is an eco-philosopher, a scholar of Buddhism and a creator of the Council of All Beings. She is known worldwide for her workshops on spiritual breakthrough and social action.

MAKEBA, QUEEN OF SHEBA, an Ethiopian royal, was according to legend seduced and impregnated through trickery by King Solomon of Israel. Years later their son paid a visit to his father in Israel, returning to Ethiopia with the stolen Tabernacle – otherwise known as the Ark of the Covenant, which is rumored to reside in Ethiopia to this day. Makeba lived and died approximately 1,000 years prior to the birth of Christ.

DANIEL C. MATT *(trans., Kook)* is the author of several books and articles on Jewish spirituality. He is a professor of Jewish mysticism at the Center for Jewish Studies, Graduate Theological Union, Berkeley, California.

CZESLAW MILOSZ *(trans., Kabir)* was born in Szetejnie, Lithuania. In the 1940s he served as a diplomat for Poland's communist regime in Washington, D.C. He is an internationally known poet and essayist and the 1980 recipient of the Nobel Prize for Literature.

STEPHEN MITCHELL *(trans., Chuang-Tzu, Rumi, Wu-Men, Hildegard of Bingen, Dogen, Rilke, Meister Eckhart, Jesus of Nazareth, psalms)*, is a translator and writer of many books including *The Bhagavad Gita: A New Translation, Rilke's Letters to a Young Poet* and *the Tao Te Ching*. A native of Brooklyn, he studied at Amherst, the University of Paris and Yale. He is currently collaborating on a book with Byron Katie.

JOHN MOYNE *(trans., Rumi)* is a Persian scholar and a Professor Emeritus of Linguistics at the City University of New York. He has collaborated with Rumi translator Coleman Barks on a number of collections of translations.

REB NACHMAN OF BRATSLAV, born in the late 1700's, was the great-grandson of the founder of the Hasidic movement. He was a saint, a Torah sage, a teacher, a mystic and a Hasidic master.

RAINER MARIA RILKE was a an early twentieth-century German poet often termed the greatest poet of our century. He is best known for his long spiritual works entitled the *Duino Elegies*.

RUMI was a thirteenth-century Sufi mystic and poet from Afghanistan. He is best known in the West for founding the dancing order known as the Whirling Dervishes.

RABBI ZALMAN SCHACHTER-SHALOMI *(trans., Abraham Joshua Heschel)* was born in Poland and raised in Vienna. In the course of his career he has been a Professor of Religion, a Hebrew school principal, a Hillel Foundation director and a consultant and spiritual guide for Jewish communities throughout the world. He has published hundreds of articles and has translated many Hasidic and Kabbalistic texts.

IZUMI SHIKIBU was a famous tenth-century Japanese writer whose work reflects a commitment to the tenets of Buddhism. She is considered the greatest woman poet of Japanese literature.

THE SIOUX was a French term that came from the Ojibwa word nadewisou. It was once used to describe a variable group of Native Americans inhabiting the Great Plains of the United States. The modern people to whom the term refers have traditionally referred to themselves as "An Alliance of Friends," which, in its various regional dialects, is spelled and pronounced "Dakhota," "Nakhota" and "Lakhota."

TREE-LEAF WOMAN was an eighth-century practitioner of Tantric Buddhism in India.

ABRAHAM TWERSKI is an internationally known psychiatrist, lecturer, author and Torah scholar who is known for his treatment of substance abusers in both the United States and Isreal. He is the founder and medical director of Gateway Rehabilitation Center, a nonprofit drug and alcohol treatment system.

WU-MEN was a thirteenth-century Chinese Zen master and the author of the famous textbook, *Wu Men Kuan (The Gateless Barrier)*

acknowledgements

thanks, to my publishers at Tallfellow Press/EveryPicture Press
for seeing an idea and letting me run with it.
to Leonard Stern and Larry Sloan for your support
and belief in me.
to my editor, Lois Sarkisian, for all your great ideas,
creativity, and friendship.
to Laura Stern, Claudia Sloan and Kristen Havens
for all your help.

to all my dear friends and family for your
suggestions, contributions, critiques and edits.
to Lucy Fisher, Marty Longbine, Robin Mitchell,
Laurie Bernhard, Babette Marcus and Cathy Kaye
for your loving help.

to Stephen Mitchell, for your inspiring adaptations
of Psalms and for allowing me to use so many of
your beautiful translations; to Rabbi Judith HaLevy
for being there when this all started, and pointing
me in the right direction; to Rabbi Mordecai Finley
for helping me with the structure of the book, for
teaching me about prayer and the inner journey;
and to Rabbi Jonathan Omer-Man for nudging me
on the spiritual path and helping me to trust my
inner voice.

to Mick Haggerty for giving shape to this book
with your brilliant design. I can't thank you enough.

to Jai Uttal for being my brother.

to Ella and Cleo, my incredible daughters, your
patience with me is so appreciated. you inspire me.
I love you guys.

and finally, to my husband, Jeff Gold, for all your love
and support, and for being my editor, critic, agent,
spiritual buddy and best friend.

credits

CHUANG-TZU
When we understand by Chuang-Tzu
From *The Enlightened Heart: An Anthology of Sacred Poetry*, translated and edited by Stephen Mitchell. Copyright ©1989 by Stephen Mitchell. Reprinted by permission of HarperCollins Publishers, Inc.

COHEN, LEONARD
God is Alive, Magic is Afoot
by Leonard Cohen and Buffy St. Marie. © 1969 Sony/ATV Songs LLC and Gypsy Boy Music, Inc. All rights on behalf of Sony/ATV Songs LLC administered by Sony/ATV Music Publishing. All rights reserved. Used by permission.

DOGEN
On the Treasury of the True Dharma Eye by Dogen. From *The Enlightened Heart: An Anthology of Sacred Poetry*, translated and edited by Stephen Mitchell. Copyright ©1989 by Stephen Mitchell. Reprinted by permission of HarperCollins Publishers, Inc.

ECKHART, MEISTER
The Eye Through Which I See God by Meister Eckhart. Translated by Stephen Mitchell, from *The Enlightened Mind: An Anthology of Sacred Prose* edited by Stephen Mitchell. Copyright ©1991 by Stephen Mitchell. Reprinted by permission of HarperCollins Publishers, Inc.

GIBRAN, KAHLIL
You would know the secret of death
From *The Prophet*, copyright 1923 by Kahlil Gibran and renewed 1951 by Administrators C.T.A. of Kahlil Gibran Estate and Mary G. Gibran. Used by permission of Alfred A. Knopf, a division of Random House, Inc.

GREEN, ARTHUR, AND HOLTZ, BARRY W.
There are times...words are spoken
There are times...gift from above
Excerpts from *Your Word is Fire* ©1993 Arthur Green and Barry W. Holtz (Woodstock, VT: Jewish Lights Publishing). Permission granted by Jewish Lights Publishing.

GREENBERG, SIDNEY & LEVINE, J.D.
Hear Our Voice
From The New Mahzor, for the High Holidays Edited by S. Greenberg and J.D. Levine The Prayer Book Press of Media Judaica, Bridgeport, CT © 2001 & 1978.

HAFIZ
I Have Learned So Much
The Sun Never Says
Reprinted from *The Gift - Poems by Hafiz, The Great Sufi Master*, edited and translated by Daniel Ladinsky, Penguin, New York, 1999. Copyright 1999 by Daniel Ladinsky. Used by the permission of the author.

HANH, THICH NHAT
Breathing in, I Calm My Body
Waking up
Looking at your hand
From *Gathas*. Reprinted from *Present Moment, Wonderful Moment: Mindfulness Verses for Daily Living* (1990) by Thich Nhat Hanh with permission of Parallax Press, Berkeley, California.

HESCHEL, ABRAHAM JOSHUA
You follow me
Translated from the Hebrew by Rabbi Zalman Schachter-Shalomi. Reprinted with his permission.

HESSE, HERMANN
Sometimes, when a bird cries out
Reprinted from *News of the Universe: Poems of Twofold Consciousness*, edited by Robert Bly, Sierra Club, San Francisco, 1980. Copyright 1980 Robert Bly. Reprinted with his permission.

HILDEGARD OF BINGEN
Holy Spirit
From *The Enlightened Heart: An Anthology of Sacred Poetry*, edited by Stephen Mitchell. Copyright © 1989 by Stephen Mitchell. Reprinted by permission of HarperCollins Publishers, Inc.

Holy are you, your name is holy
May you live to see
Reprinted from the *Kol Haneshamah: Shabbat Vehagim*. Copyright ©1996. Used by permission of the Reconstructionist Press.

JESUS OF NAZARETH
The Kingdom of God Does Not Come by Jesus of Nazareth. From *The Gospel According to Jesus* by Stephen Mitchell. Copyright ©1991 by Stephen Mitchell. Reprinted by permission of HarperCollins Publishers, Inc.

KABIR
Are you looking for me? I am in the next seat.
(Kabir says: student, tell me...)